Leonardo
The Anatomy

Text by Marco Cianchi

Design and Typeset: Giovanni Breschi

Cover illustration: detail of folio RL 19102 r, K/P 198 r (1510-1512) showing the cross-section of a human womb with an huddled foetus.

Unless otherwise specified, illustrations follow a twofold numeration: the initials RL refer to the inventory numbering of the Royal Library at Windsor used by Kenneth Clark and Carlo Pedretti in their catalogue *The Drawings of Leonardo da Vinci in the Collection of Her Majesty the Queen at Windsor Castle* (London 1968-1969, 3 v.); the initials K/P refer to the numbering used in the catalogue by Kenneth Keele and Carlo Pedretti, *Corpus degli studi anatomici nella collezione di sua maestà la Regina Elisabetta II nel castello di Windsor* (Giunti, Florence 1984, 3 v.).

Translated by: Christine Cesarini

www.giunti.it

ISBN 88-09-21484-6

© 1998 Giunti Editore S.p.A., Florence-Milan
First edition: June 1998

Reprint	Year
10 9 8 7 6	2006 2005 2004 2003

Printed by Giunti Industrie Grafiche S.p.A. – Prato (Italy)

Contents

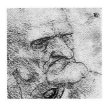

Anatomy and Drawing of the Human Body

To say that in the Renaissance man was placed at the centre of the universe may seem a truism, a handbook notion, yet one realizes that it was exactly so, when one admires the works of the great masters of the time, Leonardo da Vinci in the forefront. One may consider the well-known *Vitruvian Man*, drawn by Leonardo in the last decade of the XV century, as the first evidence of this tendency. In the picture the circle and square enclosing the human shape epitomize the dimensions of the universe at the centre of which there is

THE "MAN WORLD"
Far left, the *Vitruvian Man* (c. 1490, Accademia Galleries, Venice). Left, sketches of the "earth's body" on folio 56 r in Manuscript A (National Library, Paris).

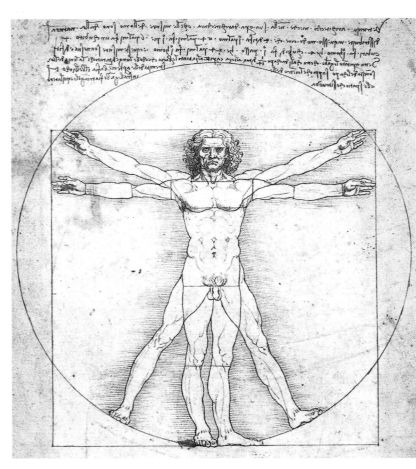

STUDY OF PROPORTIONS
Right,
drawing
(c. 1490,
RL 19132 r; K/P 27 r)
in which Leonardo
develops and
expands the study
of human proportions
by examining the
figure in a standing,
kneeling and sitting
position.

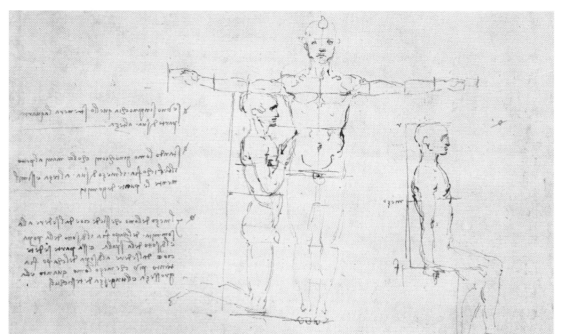

man. Conversely, one may refer to the analogy between man and the earth in a note that Leonardo wrote in one of the folios during those very years, entitled "the commencement of the book on the waters": "Man is said to be the minor world by the ancients and this expression is surely well reckoned, inasmuch as man is made of earth, water, air and fire, his body is the earth's simile. Where man has bone as a support and armour for the flesh, the earth has stones as a support for the soil; where man has a pool of blood, wherein the breathing lung increases and decreases, the earth's body has its ocean sea, that too floods and ebbs every six hours to let the earth breathe; where blood vessels branch out from the mentioned pool of blood through the human body, likewise the ocean sea fills the earth's body with countless vessels of water" (Manuscript A, 55 v). Whatever the approach one chooses to tackle the topic, the result remains unchanged: according to Leonardo man was the model, centre, microcosm reflected in the macrocosm. That was where one had to start and that was where one had to end if one truly intended finding the general law holding together the world universe.

Hence, it comes as no suprise that Leonardo considered the human body as the point of convergence of all interests and that he devoted himself to its exploration with such extraordinary dedication that he won the admiration of his contemporaries. This may be inferred by reading the words of Antonio De Beatis who, together with Cardinal of Aragon, visited an aged Leonardo in his workshop in

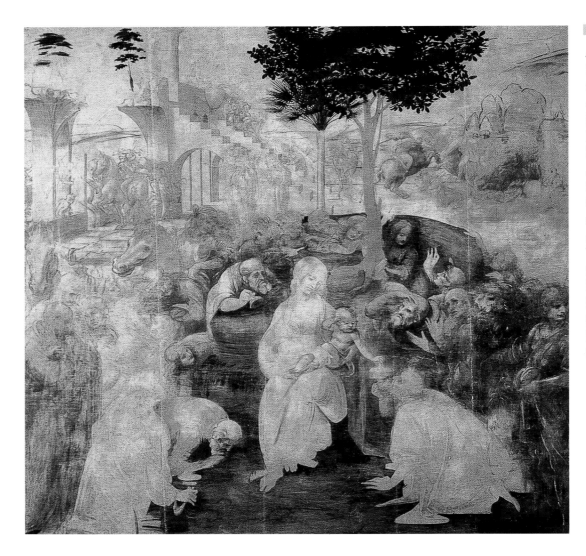

APPLIED ANATOMY
Left,
the *Adoration
of the Magi*
(1482, Uffizi,
Florence).
Next page,
Saint Jerome
in the Vatican
Gallery (c. 1482);
overleaf, detail
of *Saint Jerome*.
The pictures exemplify
that Leonardo applied
his anatomical
investigation
to painting during
his early years
in Florence.

France:" The gentleman has engaged himself in anatomy so accurately with the display of paintings, of limbs as of muscles, nerves, blood vessels, joints, as much of male bodies as of female ones, in a manner never used by anyone before. This we have seen with our own eyes and he told us he had anatomized more than thirty bodies of men and women of all ages". Ever since his training in Florence, the example set by Verrocchio, Pollaiolo and more generally the influx of Platonic culture roused in Leonardo the wish to depict not only the beauty of the proportions of the human body, but also its "animus", that is the inner flow of energy emanating from a figure in motion. Hence, the need to master anatomy became essential for Leonardo the artist: the task was accomplished in the elaborate painting of the *Adoration of the Magi* (Uffizi) and, to a greater degree, in *Saint Jerome* (Vatican Gallery), both works closing Leonardo's early florentine years.

Yet, the urge to bend anatomy (mainly concerned with the exterior rather than the interior details of the human body) to painting

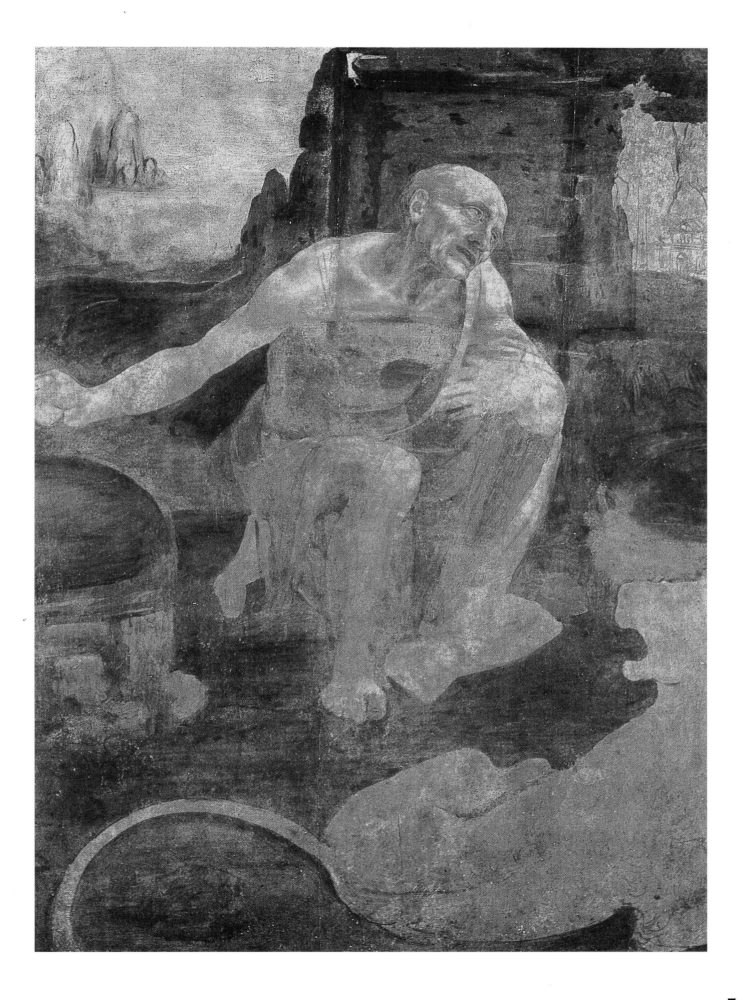

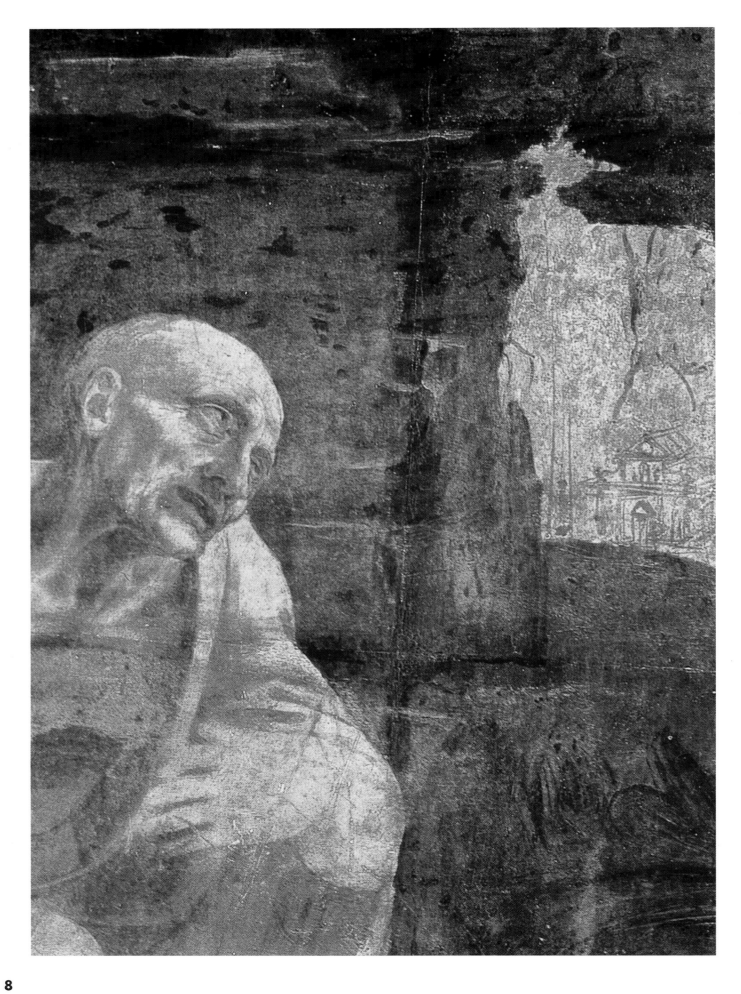

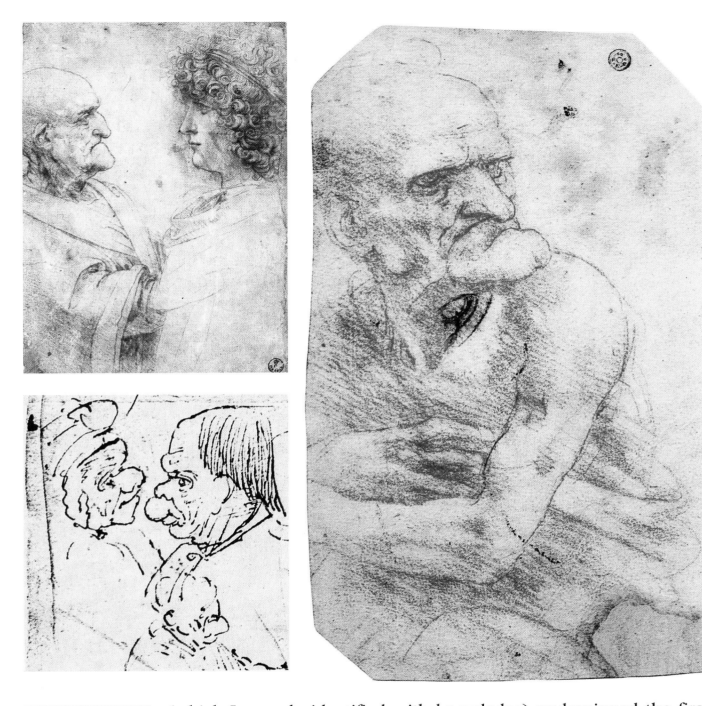

Above, caricatures
(1487-1490, *Codex
Trivulzianus*, Castello
sforzesco, Milan).
Top, two male torsos
(c. 1495, Uffizi,
Florence).
Top right,
study of an old man
(c. 1490, Gabinetto
nazionale delle stampe
e dei disegni, Rome).

(which Leonardo identified with knowledge) underpinned the first project of a treatise on the human body, later outlined during his prelude in Milan: "This work must commence with man's conception and describe the matricis aspect and how the child dwells in it [...]. Then you describe the grown man and woman, their measurments, the essence of their complexity, colour and phisiognomy [...]. Afterwards you describe how he is made of blood vessels, nerves, muscles and bones [...]. Afterwards you outline in fours stories, four universal circumstances of men: namely joy, with the various acts of laughing, and you show the reason for laughing; weeping, in several ways with its cause; strife with several motions of killing, flight, fright, savagery,

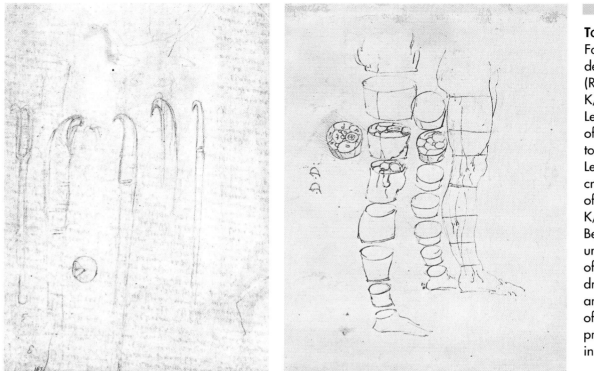

rashness, murder [...]" (RL 19037 v; K/P 81 v). At the time (around 1490), dissection, out and out a descent inside the human body, was indeed limited to a skull which Leonardo explored with the open goal of locating the point where all senses converged. He provided, in the form of a visual record, a series of extremely detailed drawings accurately set into perspective which reveal the high, philosophical longing of the artist/scientist to gain insight into the essence of the perception that takes place through the eye and eyesight. After these early anatomical investigations Leonardo set aside dissection for almost twenty years, during which he rather took interest in mechanics, hidrology, mathematics and geometry: he engaged in an exploration of wider scope that would eventually also revive his interest in man, then conceived as a "machine". Finding similarities between the functioning of mechanical instruments and the workings of the human body he stated: "Let the book of mechanical items, with its practice, precede the representation of the motion and strength of man and other animals and through these you will be able to prove all of your assertions" (RL 19009 v; K/P 143 v).

The turning-point occurred in the winter of 1507/1508 at the Hospital of Santa Maria Nuova in Florence used by Leonardo, among other things, as a bank and repository of books. There he had the opportunity of improving his knowledge of anatomy directly on the body

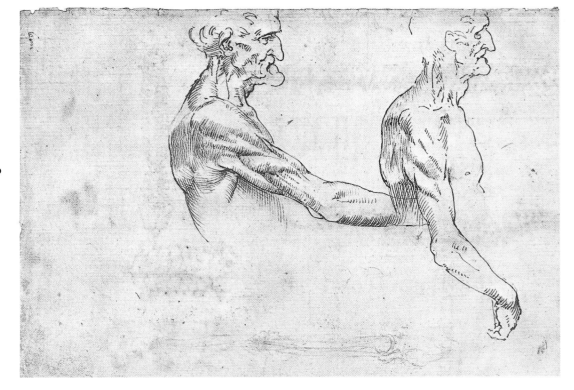

of an old man as recalled in a famous note: "The old man, a few hours before his death, told me that he had lived a hundred years, and that he felt nothing wrong with his body other than weakness. And thus while sitting upon a bed in the hospital of Santa Maria Nuova in Florence, without any movement or other sign of any mishap he passed out of this life. And I made an anatomy of him in order to see the cause of so sweet a death [...]. This anatomy I described very diligently and with great ease owing to the absence of fat and humours which greatly hinder the recognition of the parts" (K/P 69 v; RL 19027 v).

This experience was central to Leonardo's restored investigations in anatomy, because it involved direct observation of a body rather than inference from secondary medical knowledge. In the following years in Milan (1510/1511) Leonardo intensified his anatomical exploration and associated with Marcantonio della Torre, a young, though rather well-known anatomist in Pavia, establishing a mutually fruitful exchange of ideas. Finally, there is evidence of anatomical studies carried out in Rome in the hospital of Santo Spirito, between 1514 and 1515, which Leonardo interrupted having been accused by his German assistant of sorcery. In other words, from the dissection of the old man in Florence, up to the years previous to his departure for France, Leonardo studied man for over a decade, literally penetrating the marvellous human machine (and developing new investigative

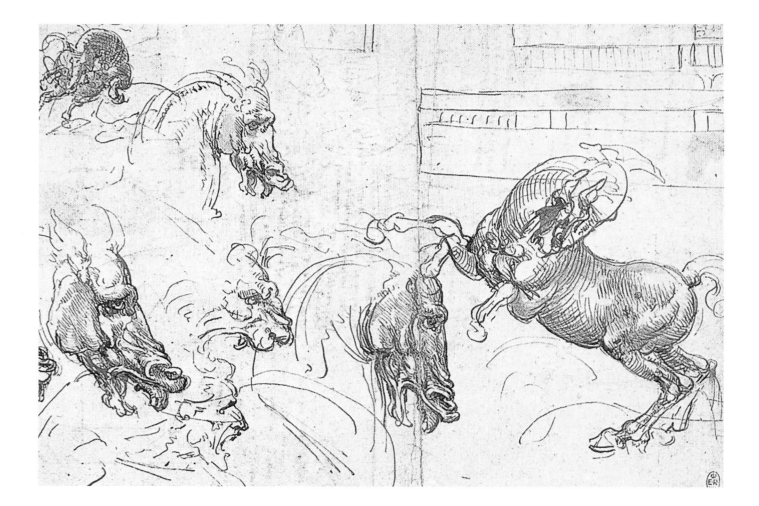

methodologies), openly seeking to explore the functions regulating its inner workings and movements. The result of his undertaking was a remarkable contribution to anatomical drawing (though less so to scientific knowledge), field in which his artistic talent greatly enhanced the contemporary rather unrefined and inaccurate representation of the human body .

Leonardo considered drawing, which he often annotated, greatly superior to writing ("Writer, which letters will you use to convey with such perfection the whole representation herein displayed by drawing? [...]. Do not interfere with matters of the eyes trying to get them through the ears"). Thus, he resolved to draw up an "anatomical atlas", in the fashion of Ptolomy's *Cosmography*, which would include several tables condensing his practice on distinct bodies, so as to offer a tool, even more useful and accurate than direct anatomical practice. This may be inferred by reading the following statement, which is an example of high scientific prose besides testifying to the often repelling conditions Leonardo endured for the love of knowledge: "And you, who says that it is better to practice anatomy rather

COMPARATIVE ANATOMY
The picture
(RL 12326 r;
c. 1504-1506)
was drawn by
Leonardo whilst
he was painting
the *Battle of Anghiari*
for the Palazzo
Vecchio in Florence;
the horse's facial
muscles are
compared with those
of a lion and an
enraged man.

FOR A GLASS MODEL
The folio (RL 19082 r; K/P 171 r) shows a series of studies on the circulation of blood through the aorta.
The studies, which may be dated to the year 1513 circa, refer to a project concerning the manufacturing of a glass model intended for the observation of the flow and downflow of fluids and the opening and closing mechanisms of the aortic valves.

than to see such drawings, would be right if it were possible to see in a single figure all the things displayed in the drawings; yet despite all your wit, in those you will only see and be aware of very few vessels [...]. And one body would not suffice for the length of time necessary to proceed from one to the other of many bodies, in order to fully understand. This I did twice to see the differences [...]. And if you love

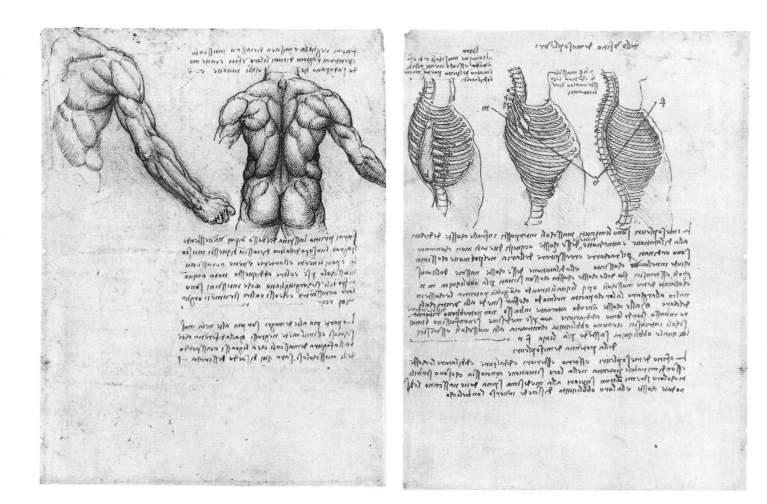

this activity, you may be hindered by the stomach, and if you aren't hindered by that, you may be hindered by fear of being at night in the company of these bodies, torn to pieces and skinned and frightening to look at. And if this doesn't hinder you, you may lack the drawing skill suitable for such representation. Or if you manage the drawing, you may lack the perspective. And if that isn't so, you may fail the arrangement of the geometrical representation or the reckoning of the strength and power of the muscles. Or you may fall short of patience. Thus you will not be diligent. Whether all these things have or haven't occurred to me, this will be judged on the basis of the one hundred and twenty books [chapters] I have composed; in these I haven't been hindered either by avarice or negligence, only by time. Good-bye" (RL 19070 v; K/P 113 r).

The collection of Leonardo's anatomical drawings, including over two hundred folios preserved in the Royal Library at Windsor (wherefrom the herein illustrations are taken), is the clearest evidence that the "judgement" called upon by Leonardo may today be expressed as a verdict in his favour.

ONE OF THE EARLY STUDIES
Above,
recto and verso of folio RL 190044; K/P 47: studies of the dorsal muscular system and the function of intercostal muscles.
Opposite,
one of Leonardo's early anatomical drawings (RL 121613 v; K/P 1 r): studies of the human body together with the picture of a frog's bone marrow (top left). The right part of the folio was known to Dürer who made a copy of it.

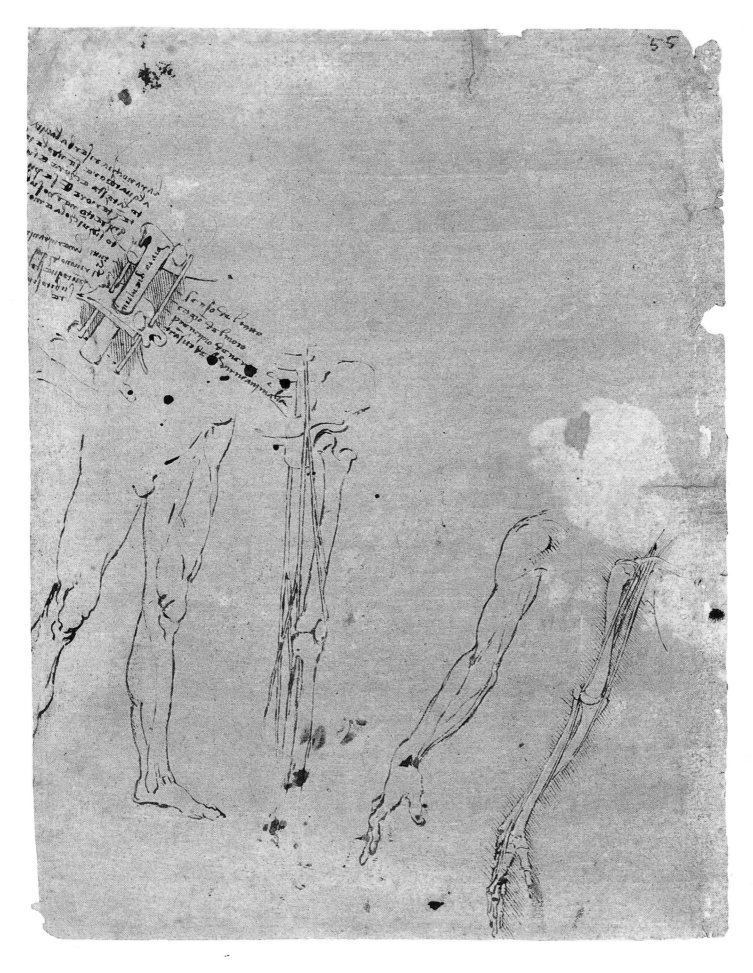

The Eye and Brain

Leonardo's very first studies in anatomy date back to 1487-1493, when he lived in Milan. They are explorations of the skull (revealing a striking accuracy and mastery of perspective) wherein Leonardo sought to find the centre of the senses, namely the "senso comune", that he considered, among other things, seat of the soul.

Of all the senses, eyesight had a special meaning for Leonardo and his contemporaries. His painting activity and his investigations in the natural world, both based on the observation of phenomena, stimulated Leonardo's interest for the eye functions and visual perception. There is evidence of this in works which are not strictly scientific, such as the *Treatise on Painting*, or in later specific explorations such as Manuscript D of 1508, entirely dedicated to the study of eyesight.

In the first years of the last decade of the XV century, Leonar-

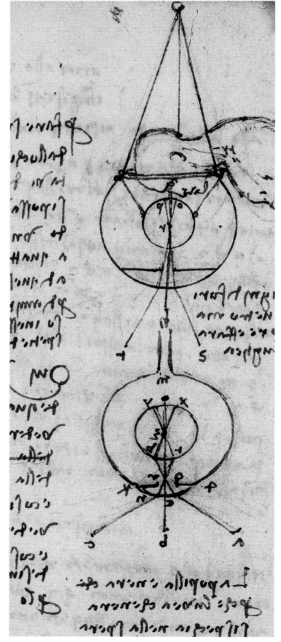

THE EYE AND BRAIN
The drawing shows an observer looking into the glass model of a human eye (1508-1509, Manuscript D, 3v, detail). Manuscript D deals with the study of the eye and the science of vision. Some of Leonardo's comments refer to his own experiments, as in the case herein.

RESEMBLING AN ONION
In this folio
(RL 12603 r;
K/P 32 r, c. 1493-
1494) Leonardo
offers
a striking
cross-section of the
human head of which
he examines every
layer as one would
with an onion cut in
half (drawn on the left
of the folio).
At the bottom there
is the horizontal
cross-section of the
upper part of a skull.

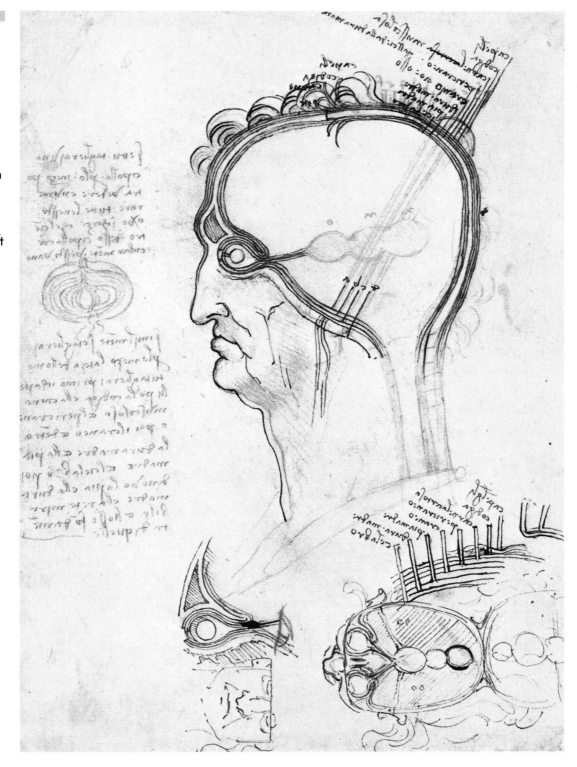

do already drew the eyeballs whence the optic nerves depart and reach the brain by following the instructions of ancient authors. Moreover, at the beginning of the XVI century he devoted himself to the study of the connections between the eye and the brain, producing the first ever made drawing of the chiasm, that is the junction point of all optic nerves. These works reveal that Leonardo slackened

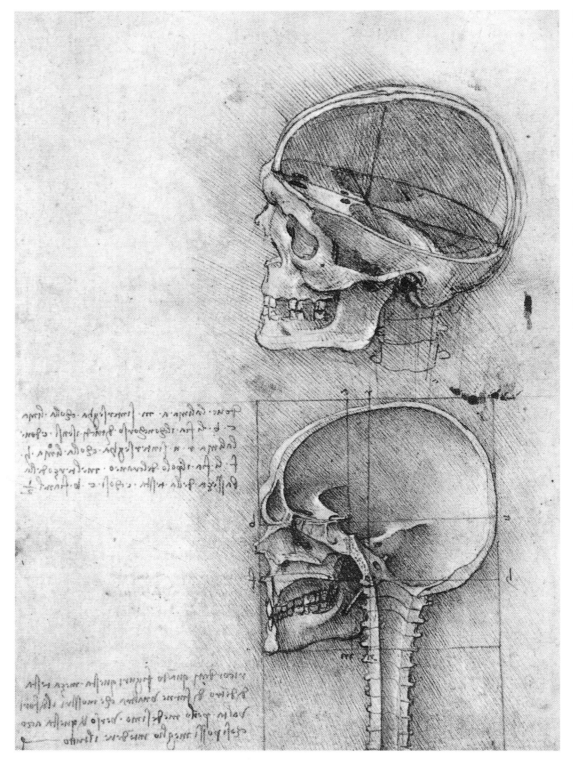

the links with tradition and worked with greater autonomy. The great master further improved his investigations of the brain ventricles (of oxen) developing a skilful sculptoreal technique involving the injection of melted wax. Once the wax had set and had been extracted from of its biological container it would show the anatomy of the chosen part.

FIRST ONE INSIDE THE EYE
Right,
in this detail
(RL 19052 r;
K/P 55 r) Leonardo
draws the eyeballs,
optical nerves,
the optic chiasm (the
point of interesection
of the optic nerves)
and was probably
the first to do so in
history.

THE SHAPE OF THE BRAIN
Right,
the drawing
(RL 1927 r;
K/P 104 r, around
1508-1509) shows
the technique
(injection of melted
wax in the cerebral
ventricles) developed
by Leonardo to
examine the interior
structure of the brain
of an ox.

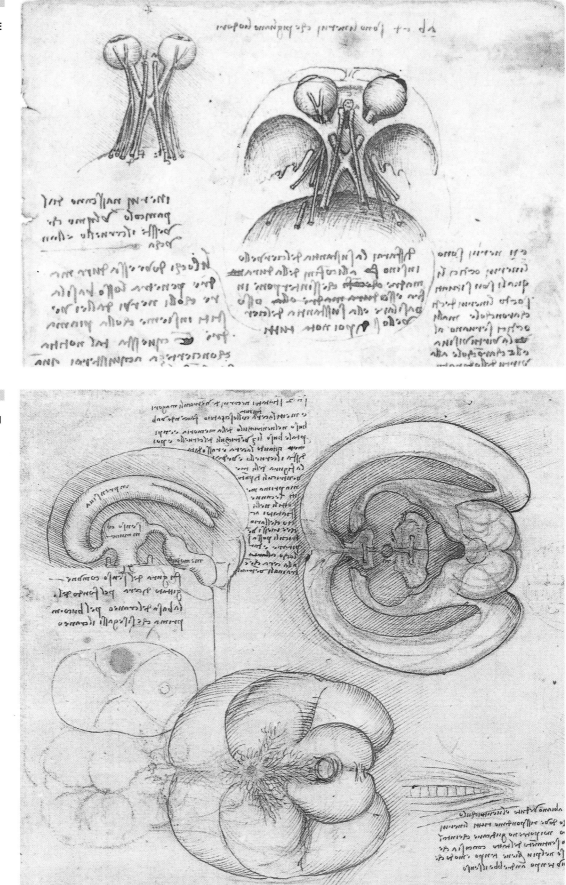

The Skeleton and Bones

Leonardo's interest in osteology (study of the bones) started around 1508-1510, in his mature years of activity, and was matched by other detailed studies on the human body, as of those on the muscles, which he carried out directly with the goal of understanding their functioning.

Shortly before this, Leonardo wrote a note or "commencement" (one of the many) for one of his studies describing the skeleton and bones in terms of a supporting framework of the human machine: "They will illustrate in drawings this instrumental element of man's body. The first three will outline the arrangement of the bone seg-

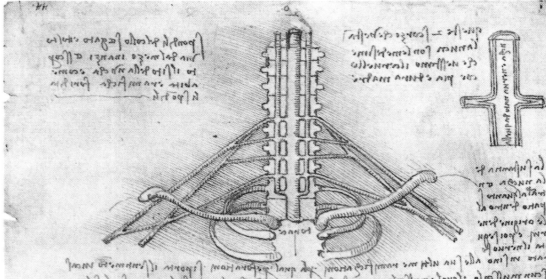

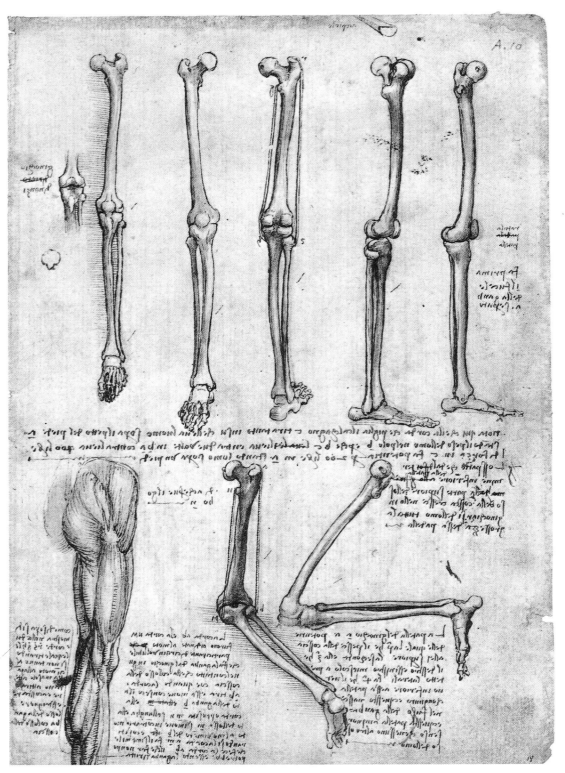

THE THREAD SYSTEM
In the folio
(RL 19008 r; K/P 140
r. c. 1508-1510)
Leonardo draws the
leg bones from three
different angles: front,
back, side. Then,
below, he draws the
knee bending. The
"thread system" used
to explain the function
of muscles is strikingly
interesting.

ments: the first will be a frontal view showing the latitutde of the segments; the second will be a lateral view displaying the profundity of the whole structure and of the single items; the third will display a back view of the bones. Then they will draw three more illustrations of the same items, with the bones' sections, showing their

SHOULDER AND FOOT
The bones of the foot and shoulder are the highlight of folio RL 190011 r; K/P 145 r. The drawings date back to years 1508-1510, as proof that in those years Leonardo had perfectioned his knowledge of anatomy and acquired an exceptional ability in drawing.

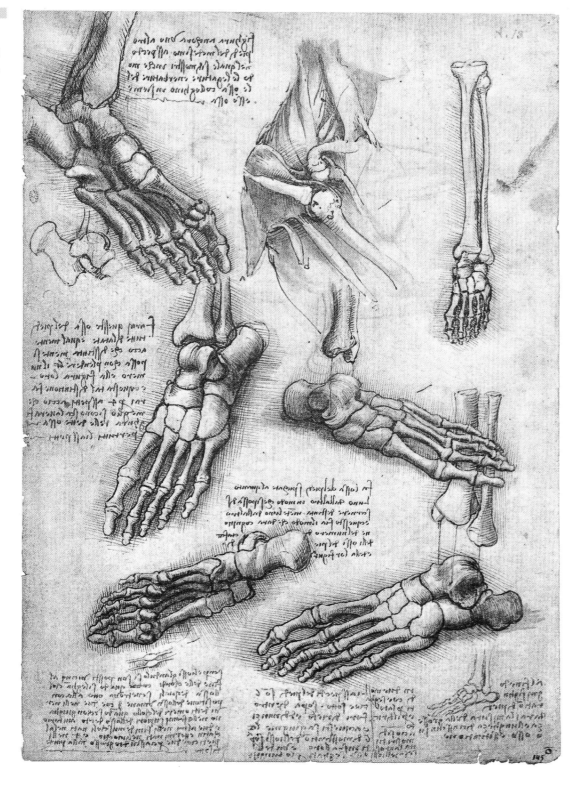

thickness and their hollowness" (K/P 81 v). This passage is also useful to grasp the drawing technique Leonardo had in mind, which involved the representation of the skeleton and also of the individual bones from different angles and sectional layers. Observing the drawings referred to in this section, one gathers that they are con-

PROJECTING COMPARISONS
At the top on the right of folio RL 19009 v; K/P 143 v of around 1508-1510, Leonardo draws with masterly skill the hand bones and the tendons of a finger. In his notes he resolves to draw several comparative pictures of the hands of an old man, a young man and a youth.

sidered among the best of Leonardo's studies, and rightly so, being examples of great anatomical accuracy and refined art.

To obtain a better picture often Leonardo drew items separately, as in the bones of the foot and hand, but also in the beautiful outline of the spine; by so doing he managed to explain the

MAN MACHINE
The movements of the arm bones produced by muscles, especially the biceps (RL 19000 v; K/P 135 v, 1508-1510) are related to Leonardo's interest in the mechanical sciences. Man, at that stage conceived as a machine, is in fact sectioned and investigated with the aim of revealing his gearings and mechanisms.

complex functioning of joints. At other times Leonardo resorted to views from above and below of the same anatomical part, or, as in the case of the long bones of the arm and leg, he focused on their mechanical function as levers for lifting, lowering, rotating and bending limbs.

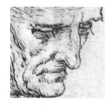

The Muscles and Nerves

L eonardo's study of the muscular apparatus (myology), mainly carried out between 1505 and 1510, included a series of drawings unanimously regarded as the most striking and impressive of the whole anatomical collection. The investigation on muscles was contemporary to that of the skeleton and bones, though it was less successful in scientific terms. This owing both to the fact that such exploration posed more problems and that Leonardo pioneered this field of study at a time when myology was greatly neglected.

The outline used throughout Leonardo's scientific work in anatomy displayed initial observations of the external details (disclosing his artistic concern) and concluded with a gradual and

THE OUTLINE OF MUSCLES
Left,
studies of male legs (RL 12631 r and 12633 r; K/P 89 r and v, c. 1508) focusing on thighs which Leonardo compares to those of frogs and hares.
Opposite,
(RL 19013 v; K/P 144 v, c. 1508-1510) a striking representation of the shoulder muscles at three different stages of dissection, along with drawings of the foot bones.

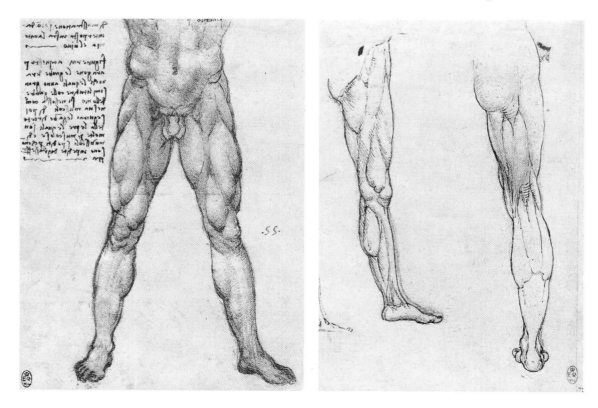

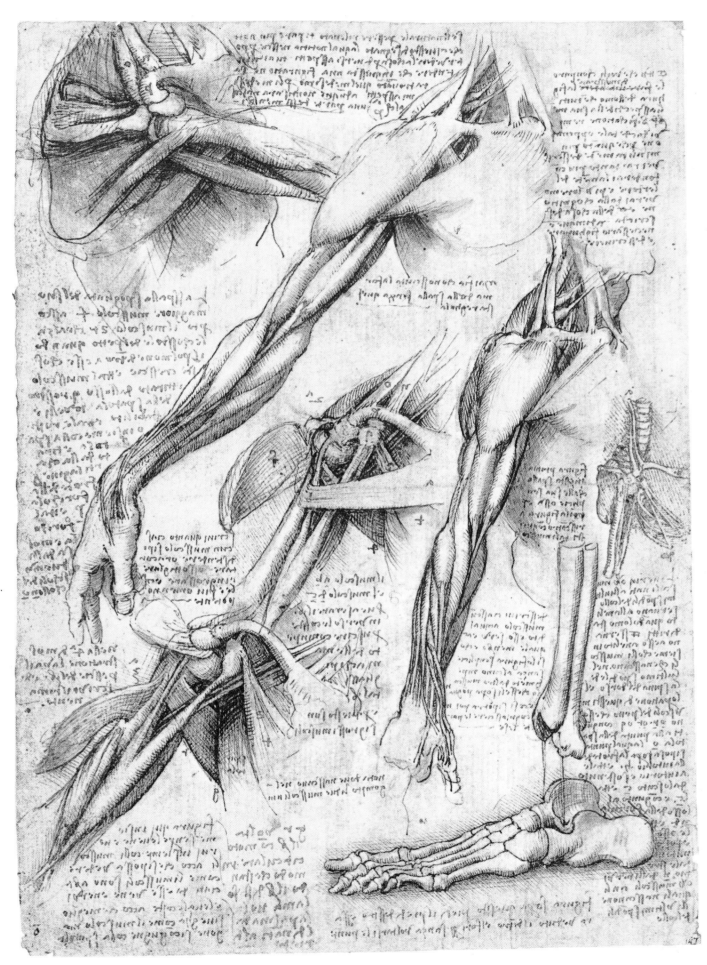

thorough analysis of the muscles' phisiology and mechanics. To simplify the explanation Leonardo conceived a system, whereby, in the drawings, the tendons and muscles were replaced by strings and threads: "If you have drawn the bones of the hand and you wish to draw the muscles covering and joining the bones, then

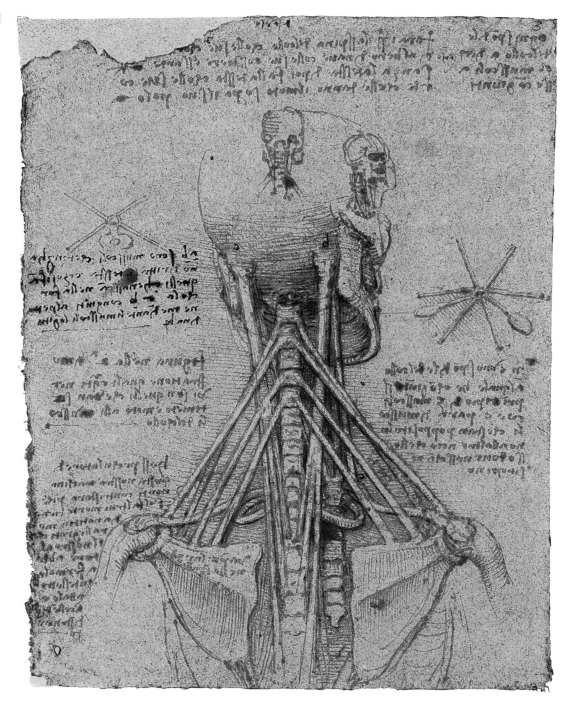

draw threads, though not muscles. I say threads and not lines, so that one can see which muscle rests over or under the other given that one would not be able to do so with simple lines. And once this has been done, besides, draw another hand showing the real outline of muscles [...]".

Leonardo used this technique of drawing (often from several angles) the muscles of the leg, torso, arms, neck, shoulder and face: in the latter case he openly sought to explain the role of muscles in facial miming. Linked to the study of the muscles was that of the

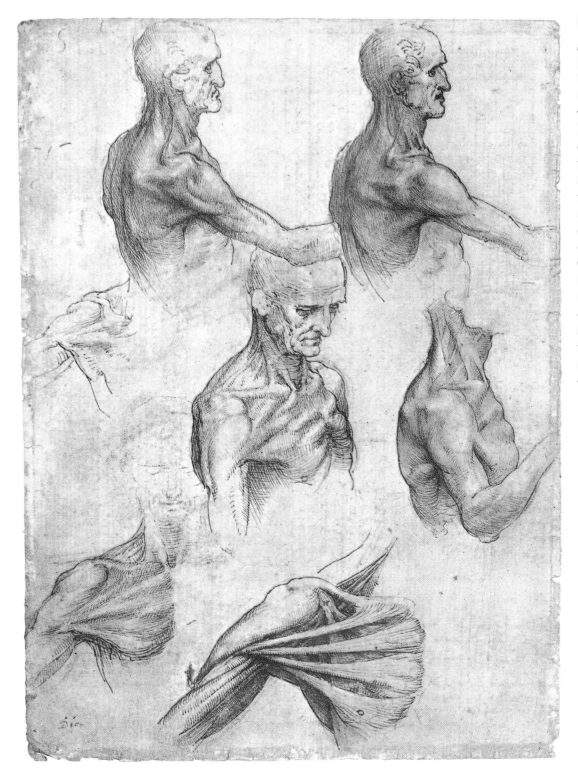

MUSCLES IN ACTION
Left,
in this folio
(RL 19001; K/P 136
v, c. 1508-1510)
Leonardo carries out
a series of studies of
the muscles of the
shoulder, neck and
torso, rotating the
subject in order to
catch its different
angles.
Opposite,
(RL 19017 r;
K/P 151 r,
c. 1508-1510) the
simplilfied system of
threads (or strings)
shows the movement
of legs and feet.

nerves ("which give voluntary motion to the limbs"): after his juvenile experiments on frogs and monkeys, Leonardo greatly improved his knowledge of the human central nervous system and outlined the so-called "tree of the nerves" that "descends from the brain and nape stretching along the spine and spreading along the arms and legs".

The Heart and Blood Vessels

Leonardo's exploration of the cardiovascular system may be divided in two chronologically distinct periods of his life. A drawing showing the "Tree of the Vessels" dates back to the last decade of the XV century and was heavily influenced by the old-established theories of the time, namely those by Galen and the medieval beliefs by Mondino.

In both cases, through reading rather than experience, Leonardo had acquired such knowledge, whereby the vascular "Tree" stemmed from the liver: he will eventually become converted to the notion that it is the heart to have a central role. Leonardo began accurate studies of the heart only later in life, around 1513,

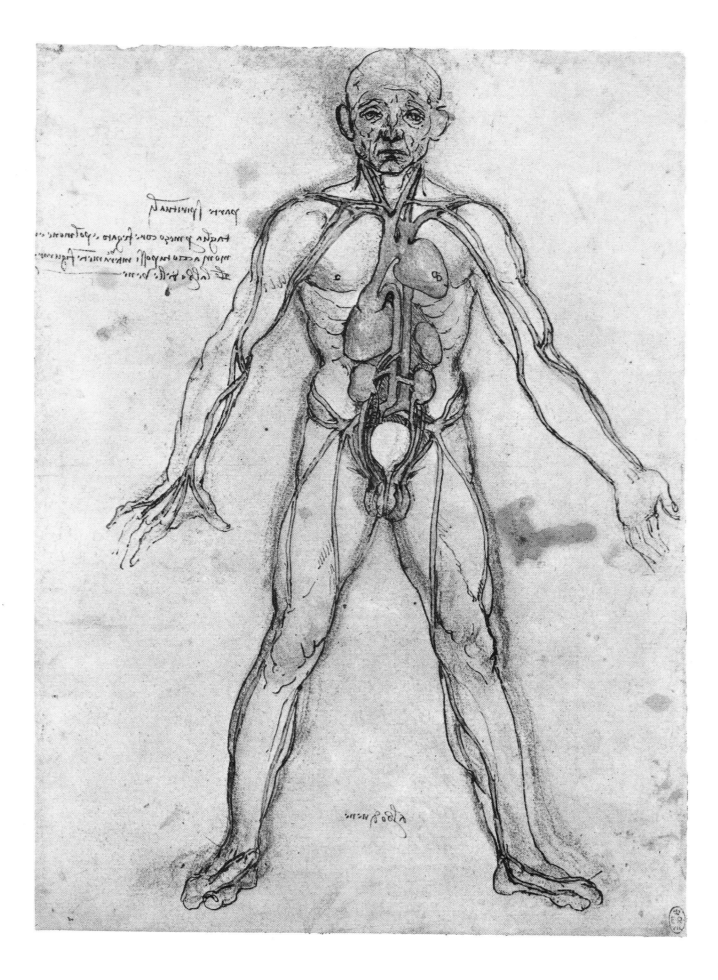

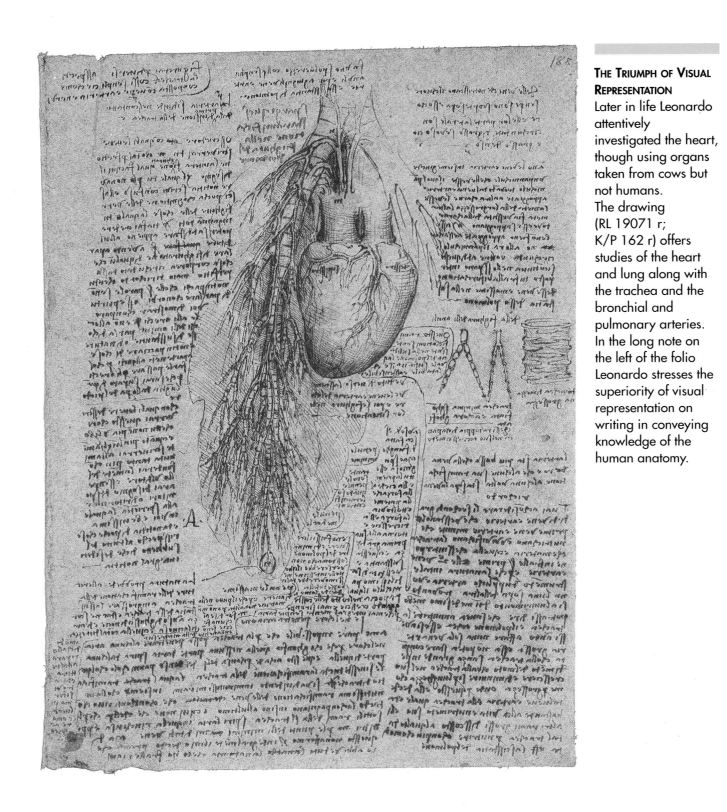

THE TRIUMPH OF VISUAL REPRESENTATION
Later in life Leonardo attentively investigated the heart, though using organs taken from cows but not humans.
The drawing (RL 19071 r; K/P 162 r) offers studies of the heart and lung along with the trachea and the bronchial and pulmonary arteries. In the long note on the left of the folio Leonardo stresses the superiority of visual representation on writing in conveying knowledge of the human anatomy.

and carried out dissections only on animals (mainly oxen), but not on human bodies.

The investigation led Leonardo to revise current theories and to overcome mistakes made by his predecessors. Yet there is no doubt that Leonardo was never in the position to develop a new comprehensive and holistic theory of the circulatory system, be-

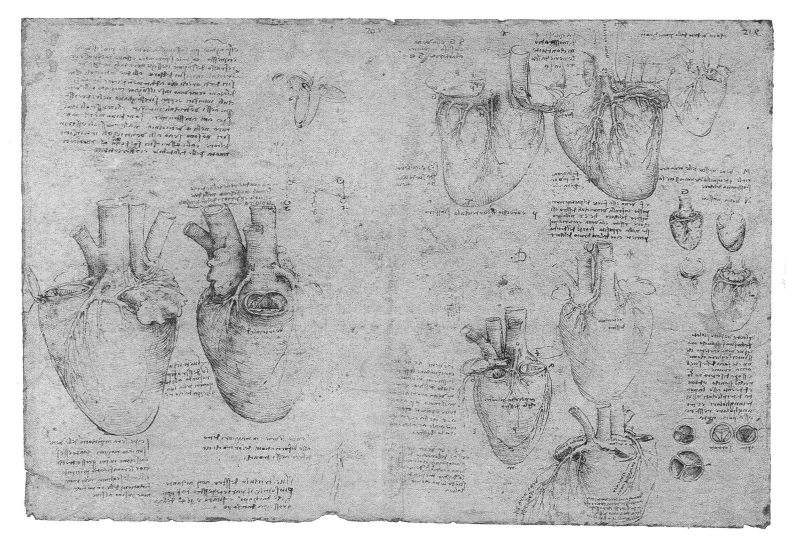

FROM DIFFERENT ANGLES
On the left,
the drawing
(RL 19073-74 v;
K/P 166 v) displays
the heart of an ox
with the pulmonary
artery sectioned at
the base.
On the right,
there are other studies
of the heart drawn
from different angles
showing surperficial
arteries and veins.

cause basically he remained faithful to the principles of the Galenical school.

He put great effort in understanding the opening and closing mechanism of the valves (especially the aortic) and the flow of blood whithin the heart. In order to do this he made use of the practical notions gathered during his experience as hidraulic engineer, when, having to build canals, he studied in detail phenomena linked to the flow of the waters.

Leonardo managed to create a glass model of the aorta obtained by making a wax mould of the artery of an ox, whithin which he introduced liquids to perform experiments on the blood flow.

Some of Leonardo's drawings on superficial blood vessels of the arm, abdomen and torso are extremely accurate and testify to his lengthy exploration aimed at a more detailed and scientific understanding of the human body.

The Respiratory, Nutritional, Digestive Apparatuses

Leonardo's studies of the respiratory system were carried out in maturity, between 1506 and 1510, and were mainly centred on animals.

He investigated in detail the larynx and trachea also because he sought to gain insight in the process of sound emission. With reference to this Leonardo wrote in a note: "Try to see how sound is produced in the front of the trachea. This may be accomplished by separating the trachea along with the lungs of a human body. Thus having filled the lung with air and having fastly blocked it one can see immediately how the tracheal pipe produces voice. And this one can see and hear accurately with the throat of a swan

STUDIES OF ANIMALS
On the same folio
(RL 19039 v and r;
K/P 61 v and r,
1506-1508)
Leonardo draws the
inner organs of an
abdomen, having
carried out the
dissection according
to the instructions
contained
in the medieval work
on anatomy
by Mondino.
Left, the notes next
to the drawing
explain the position
of the spleen,
stomach and liver.
Opposite,
(RL 19104 v;
K/P 107 r,
1506-1508)
the representation
of the internal
organs of the torso
and abdomen focuses
on the heart,
the vascular system
and the lungs.
These studies
for the most part
involve the dissection
of animals,
mainly cows.

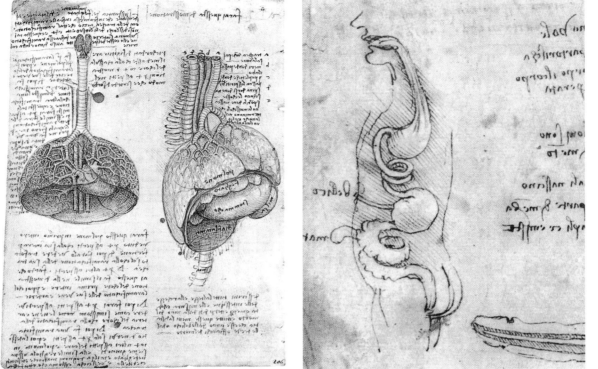

or goose, which can be made to sing after its death many a time". The lungs (of pigs, but not humans) often appeared in Leonardo's drawings with the trachea and the bronchi branching out and both bronchial and pulmonary arteries.

However, despite some of Leonardo's precious contributions, it is clear that his idea of the respiratory apparatus did not break away from the classical medical theories revisited during the Middle Ages which assumed that air filled the lungs. Leonardo meditated at length over the flow and downflow of air whithout finding any explanation.

With regards to the nutritional and digestive apparatus, after the rather schematic representations of his early years, Leonardo went on to draw the relevant organs with extraordinary accuracy having benefited from the dissections carried out on the body of an old man in Florence in the winter between 1507 an 1508 (see p. 10).

The study of the esophagus and stomach includes the complex intestinal tangle as well as the spleen and liver which are correctly located. Unaware of the rythmical contraction (peristalsis) that allow the passing of food along the intestine, Leonardo erroneously concluded that during breathing the diaphragm and the abdominal walls accomplished the task.

INSIDE THE HUMAN BODY
Right,
verso and recto of
folio RL 19031; K/P
73 v, of 1506-1508
showing the drawing
of the stomach and
the intestines.
Below left,
(RL 19051 v; K/P 60
v) the liver and the
network of hepatic
blood vessels;
right (RL 19020; K/P
57 r) the intestinal
mesentery.

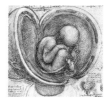

The Reproduction and Genital Organs

Also with reference to the study of the genital organs involved in the reproduction of life one may distinguish two stages: Leonardo first drew rather traditional, though vivid and eloquent, pictures of the organs (around 1492-1494), then he produced the extraordinarily accurate drawings of 1510-1512, which became famous owing to a series of representations that are considered the best in the whole anatomical collection.

With reference to the male body he studied and displayed the urinary ducts leading to the bladder and the ejaculatory canal along which the semen flows, managing to understand how the haernias form in the scrotum. As to the female body (difficult to obtain for dissection) Leonardo drew the external and internal gen-

THE ORIGINS OF LIFE
Leonardo's magnificent investigations on the origins of life date back to 1510-1512. Left, the detail on folio RL 19101 v; K/P 197 r displays a foetus along with three cross-sections of the umbilical cord and studies of the elbow and forearm bones.

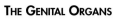

THE GENITAL ORGANS
Centrally the folio
(RL 19098 v; K/P
106 v, 1508-1509)
displays the drawings
of male genital
organs together with
the gall-bladder and
the seminal and
urinary canals.
At the top on the left,
the drawing of the
lung of a pig.

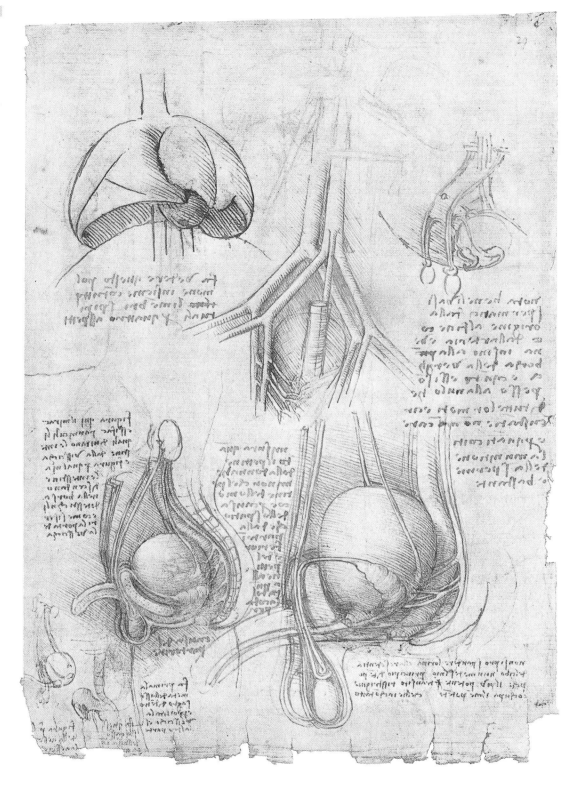

itals, often comparing them in the same folio with the male organs. He investigated the ovaries and the uterus during pregnancy and explained the pictures with notes as in the following example: "The child is in the womb surrounded by water because heavy objects weight less in water than in the air, and more so if the wa-

41

ANIMAL MODELS
Often Leonardo uses animals to gain insight in anatomy as in this study (RL 19055 r; K/P 52 r, 1506-1508) of a cow's womb drawn from the outside (above) and the inside (below). In order to explore the womb's inner cavity he used a special drawing technique showing, against the light, the foetus upside-down and the cotyledons (resembling flowers) by which the maternal blood flows.

ter is slimy and dense. And thus this water distributes its weight and that of the baby on the bottom and on the sides of the matrix". Leonardo took up embryology (the study of embryos) reaching striking achievements, though he sometimes transferred to the human body aspects observed on cows. Yet, it is known that Leonardo had obtained a human foetus almost seven months old, for his dissections. The relevant drawings show from different an-

AN EXTRAORDINARY SECTION

In folio RL 19102 r;
K/P 198 r,
dated 1510-1512,
Leonardo draws a
cross-section of the
human womb
carrying a foetus and
the umbilical cord.
The rest of the
drawings show the
passage of maternal
blood from the
placenta to the foetus,
which erroneously
include the cotyledons
found in cows'
foetuses.

At the two following
pages:
page 44
Folio RL 19005 r; K/P
141r:
Vena basilica;
perforation below the
skin and joint with
deep blood vessels.
Page 45
Folio RL 19003 r;
K/P 137 r:
Muscles and veins of
the shoulder.

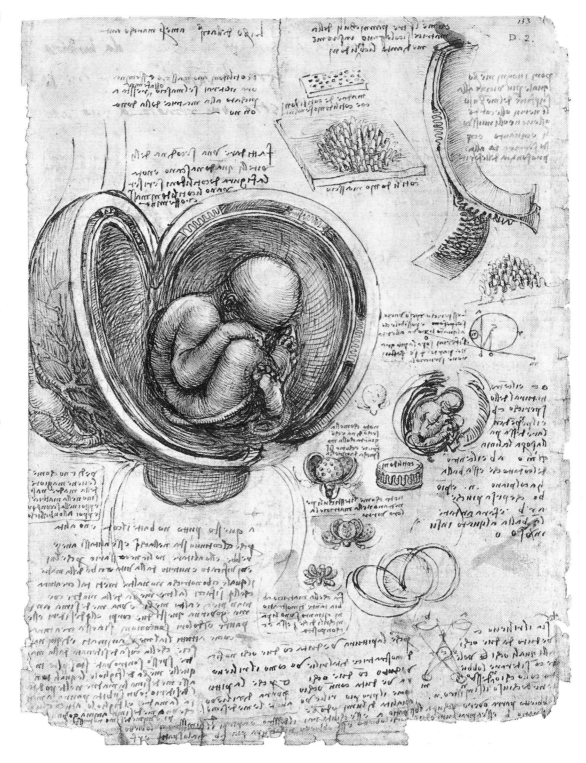

gles the foetus huddled in the uterus with its umbilical cord, which Leonardo described "of the length of the child at any age". Finally, besides observing the length and position of the umbilical cord, Leonardo explored, trying to understand, that spectacular process governing the development of the foetus inside the maternal womb up to the birth of a new life.

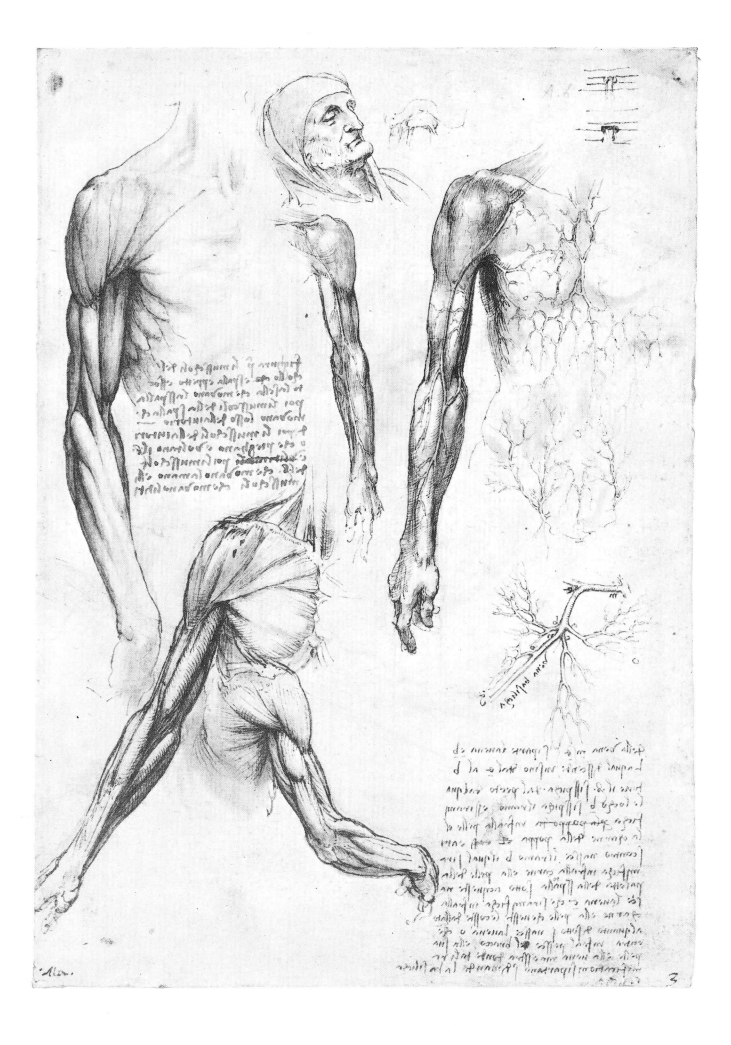

STUDIES OF THE SKULL AND BRAIN

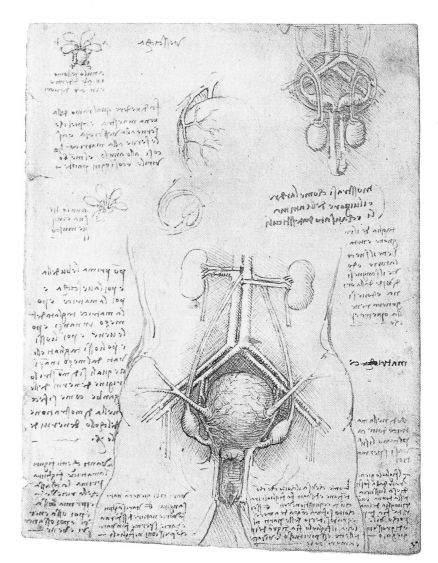

This folio, included in Manuscript B on anatomy and preserved in the Royal Library at Windsor (and part of the work *Corpus dei disegni anatomici* by Keele/Pedretti, items 54 and 55), displays on the verso Leonardo's most advanced studies of the brain. Above, inside the lateral view of a head there is the diagram of the cerebral ventricles, based on the evidence Leonardo had gathered through his experiments injecting melted wax. The cranial nerves spread out from the bottom of the brain. The picture below, which is even more remarkable, shows the expanded view of the same bodily part drawn three-dimensionally. The cranial vault, the brain with the nerves identified by letters, the bottom of the skull sectioned at the forehead, all of these items are displayed in such manner so as to provide an overall picture of the single parts. On the recto of the folio (on the right) there are studies of the uro-genital apparatus with a view from the top of the ejaculatory duct.

Studies of the Skull and Brain
1508
cm 19,3 x 13,9.
Schloss Museum, Weimar

INSIDE THE BRAIN
The verso of the
so-called *Weimar
Folio* shows the
ventricles, eyeballs
with optic nerves
and cranial nerves.
In the recto
(opposite page)
Leonardo draws
the anatomy of the
urogenital tract:
at the top on the right,
there are the male
organs, whilst the
large drawing shows
the frontal study of the
genital system
of a woman with
the womb centrally.

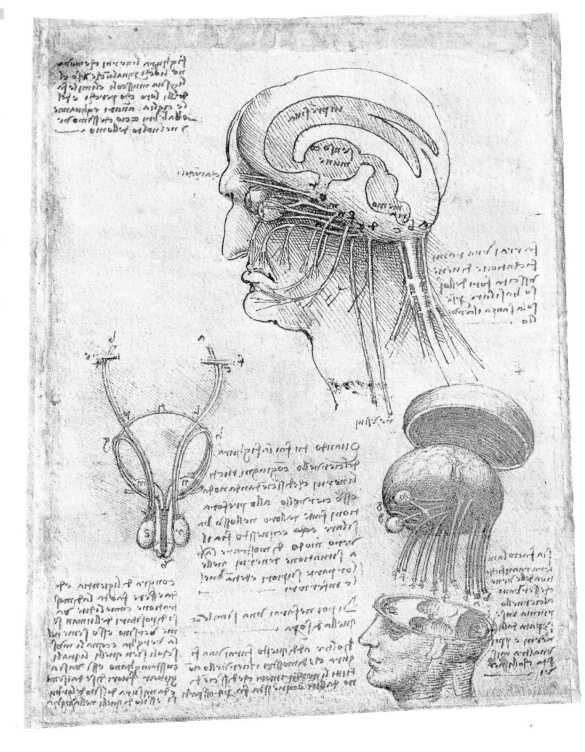

WOMB AND OVARIES
Detail of the recto of
the *Weimar Folio*
displaying a swollen
womb and the
ovaries at the sides.

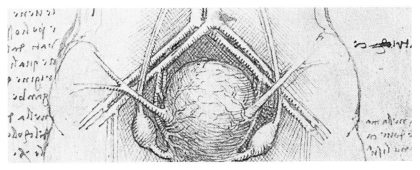

STUDIES OF THE THROAT AND LEG

On the right hand-side of the folio, the study of the muscles of a leg stands out surrounded by a series of sketches of the throat organs involved in the production of sounds. Here too, the parts are first drawn separately and then assembled together.

On the left of the folio, there are the tongue, uvula, pharynx, trachea and esophagus.

The drawings on the right of the leg display the epiglottis and the mechanism through which food is passed into the esophagus.

At the centre, below, there are the vocal cords viewed from the front and the top.

Leonardo thought that the sounds making one's voice (phonation) were generated by air vortices formed during expiration, when the air passes through the vocal cords to reach the wider cavity of the throat.

FIRST THE LEG
The leg standing out on the right must have been drawn first; some time later it was followed by representations of the throat organs.

A THRONGED FOLIO
The folio is a masterpiece of images and writing owing to its thronged and varied abundance of details and overall pictures.

MULTIPLE STUDIES ON PHONATION
Below, in the detail, Leonardo draws several studies of phonation; the tongue, larynx and vocal cords are drawn from a top view.

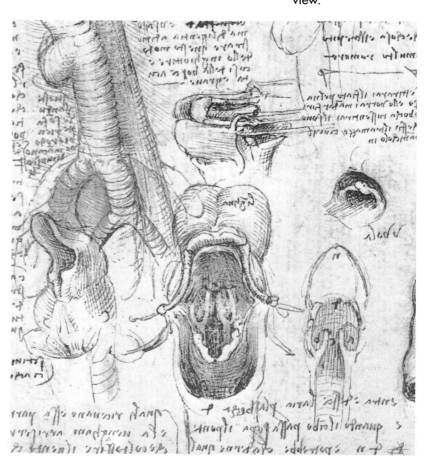

Studies of the Throat and Leg
1509-1510
RL 19002 r;
K/P 134 r

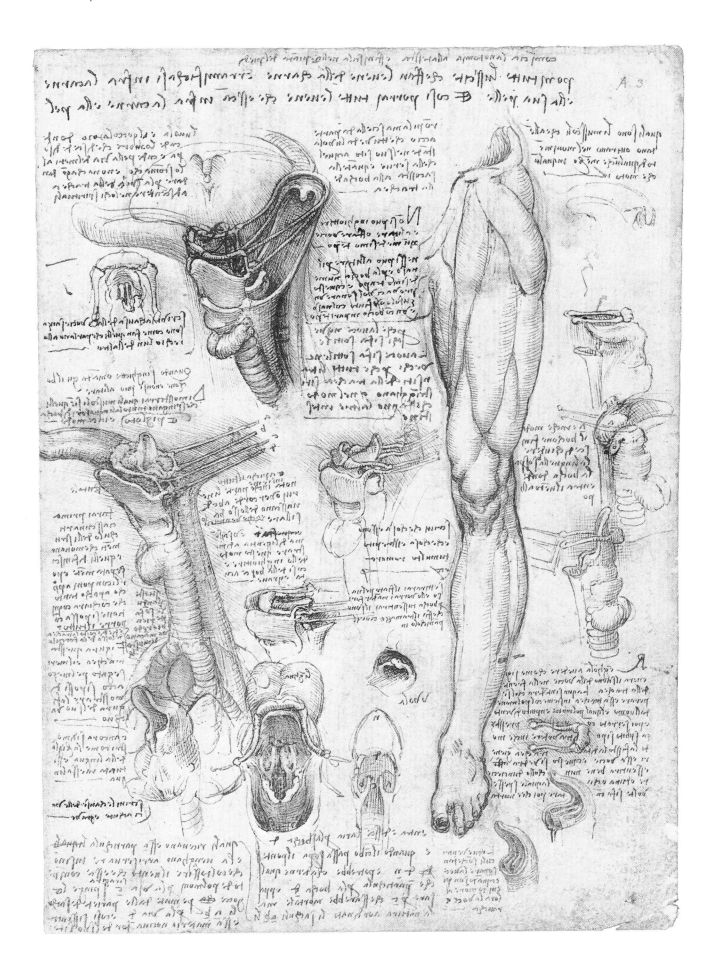

STUDY OF SKELETON

O ne of the most admired studies of the human skeleton is this folio in which Leonardo depicted a group of drawings of the sternum and the bones of the limbs from different angles.

Above on the right and below on the left there is the thoracic cage which, however, shows a few mistakes (the number of sternum segments is herein given as seven) handed down by medieval medical thories, namely that of Mondino. The scapula too, clearly shown on the left, seems to be exceedingly long.

The shoulder joint was Leonardo's main focus in the drawing below on the left, in which the use of letters to identify the various bones was matched by the handwritten notes in the margin.

The illustration of the lower limbs standing upright accurately reproduces their position with regards to the spine and pelvis. The rotula too is accurately drawn in its exact position in the knee-joint.

View of Torso and Leg Bones
1509-1510
RL 10012 r
K/P 142 r

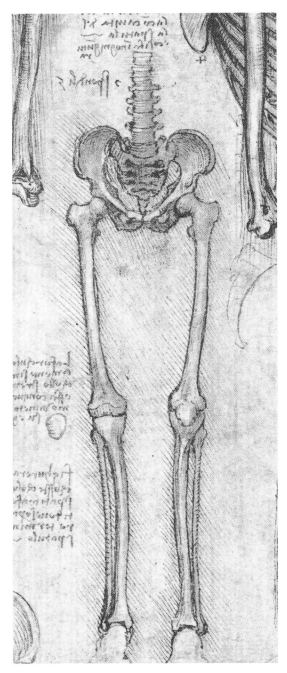

THE MOST COMPLETE RECORD
With these drawings Leonardo offers the most complete record of representations of the human skeleton in his anatomical studies. The notes added to the drawings mainly provide explanations on the ribs, scapula and shoulder joint.
Left,
the detail displays a frontal view of the lower limbs showing the pelvis and the spine.

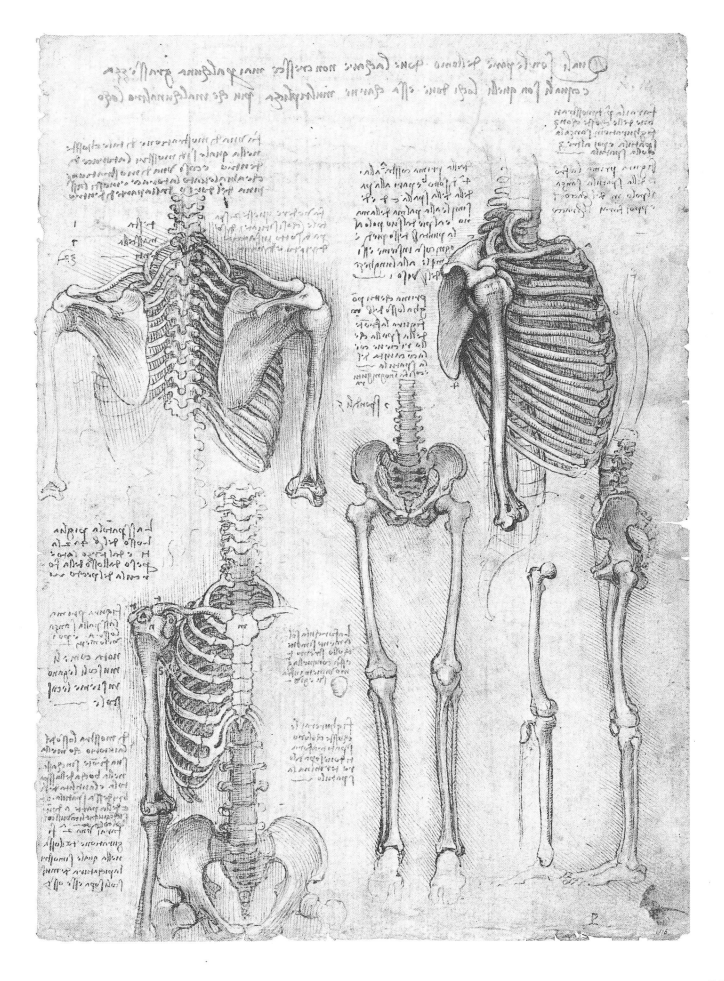

STUDY OF THE MUSCLES OF THE SHOULDER

The folio shows the role of the muscles involved in the movement of the shoulder joint. Above on the right, Leonardo outlined the muscular apparatus by resorting to the system of threads or lines to explain in simple terms how movement was produced. In this regards he wrote: "draw threads before muscles; such threads are to indicate the site of muscles and have their ends converging where muscles join bones. This will allow a better understanding when you draw all the muscles, one over the other. Otherwise your drawing will appear confused to the eyes of others".

The male figure, drawn from two different angles, shows the pectoral muscles and the role of dorsal muscles involved in lifting the arm; the pictures on the left of the folio display further details, at times with some variations and specifications. Overall the folio is a remarkable example of anatomical drawing.

View of Shoulder Muscles
1509-1510
RL 19003 v
K/P 137 v

THE INITIAL DRAWING
The drawing at the top on the right shows the thread diagram of the muscles involved in the movement of the shoulder and may have inspired Leonardo's drawings on the rest of the page.

NO COMMENT
All the drawings on the folio are brilliant examples of Leonardo's anatomical studies, so much so that in some instances the annotations seem superfluous.

THE GREAT PECTORAL MUSCLE
Below, a detail from the folio showing the fenestration of the great pectoral and underneath it the small pectoral.

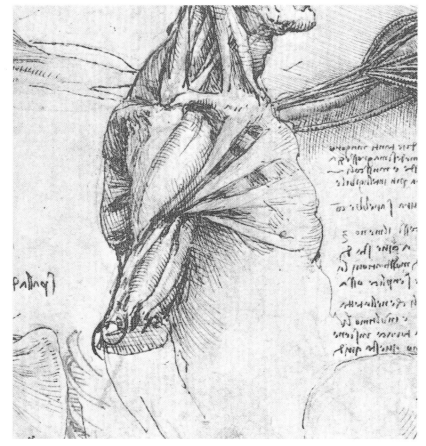

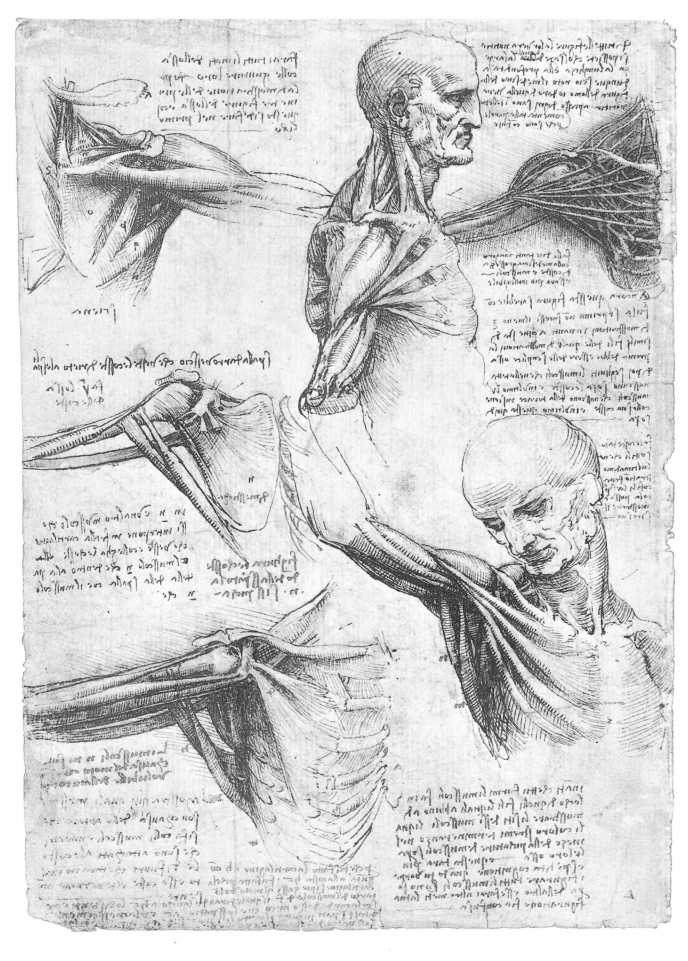

STUDY OF THE MUSCLES OF THE ARM, HAND AND FACE

The folio displays studies of the superficial muscles of the arm, human facial muscles involved in miming and muscles of the hand.

The top note includes a tentative of classification of muscles according to their form and their connection to the bones via tendons; the drawings in the left and right margins are studies of the superficial muscles of the arm, with details of the deltoid.

Centrally, two profiles of the same face display an accurate analysis of the muscles involved in facial expression with identifying letters explained in the note: "h is the muscle of rage, p is the muscle of pain, g is the muscle of bite, gnm is the same muscle, ot is the muscle of rage".

In the open hand below, there is, on the right, a study of the ulnar artery and tendons, on the left, a study of the nerves of the hand and fingers.

View of the Muscles of the Arm,
Hand and Face
1509-1510
RL 19012 v
K/P 142 v

THE MINIATURIST
Below,
detail of the superficial blood vessels of an arm (RL 19027 r; K/P 69 r). According to Leonardo's annotation the arm used as a model was that of a "Francis the Miniaturist".

LINKS WITH PAINTING
Leonardo's anatomical studies and his artistic activity are clearly linked, as may be gathered observing the expressions of terror, indignation or rage which often show the faces in his drawings or paintings.

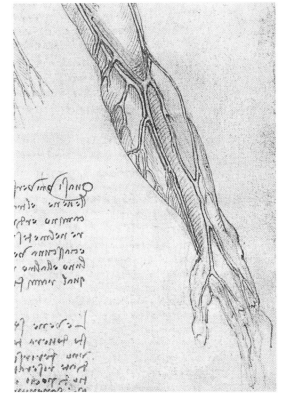

COITION OF HEMISECTED MAN AND WOMAN

The drawings on this folio include studies of human genital and reproductive apparatuses, clearly influenced by the theories of classical and medieval authors which Leonardo followed in the early years of his anatomical studies in Milan, around 1490. It was commonly believed (according to a theory dating back to Plato) that semen was contained in the marrow bone and flowed to the genitals through the spine. Indeed, Leonardo took his time in drawing the spine (the curvature is accurate) and the seminal ducts.

However, it may be pointed out that Leonardo himself was critical of those theories in that same folio and he reviewed them later on through his direct experience of dissection. Below, the sectioned penis shows the two ducts (for urine and semen) already described by Mondino.

Coition of Hemisected
Man and Woman
c. 1493
RL 19097 v
K/P 35 r

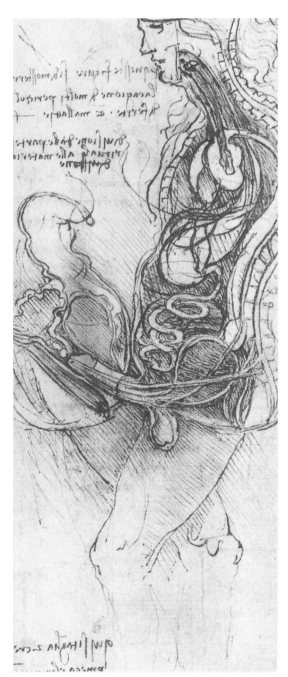

THE INFLUENCE OF CLASSICAL THEORIES
The folio with the lovers in coition is one of Leonardo's most well-known drawings, mainly because the subject arouses the viewer's curiosity; from an anatomical point of view the study is off-based because heavily influenced by classical theories in medicine, rather than being grounded on direct experience.
The note at the top, in the middle of the folio, says: "I expose to men the origin of their first, or perhaps second, reason for existing".
The drawing of the digestive system on the left margin of the folio seems scant and also inaccurate.

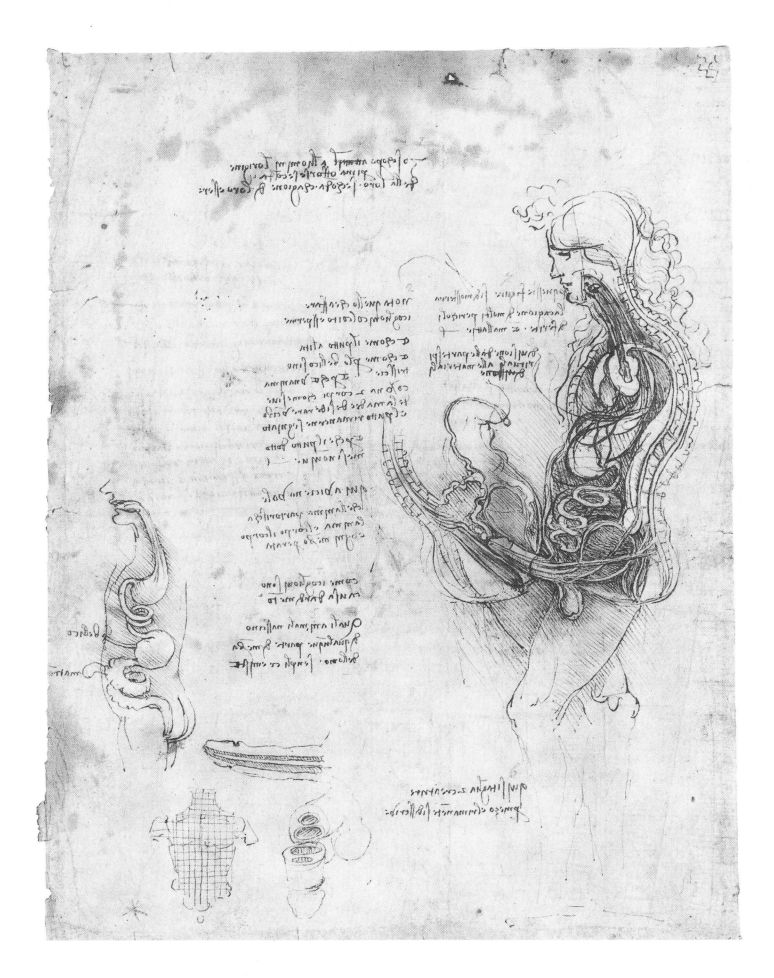

FEMALE INTERNAL ORGANS

One of Leonardo's plans included the realization of an anatomical atlas, similarly to Ptolomy's *Cosmography*, containing a display of human organs. The last three of the twenty-four tables he had in mind were intended to show an overall picture of the internal organs of the female body. Evidence of this project is given by the picture on the piece of drawing paper folded and pierced (on the right, the verso of the folio) because it was used to make copies and improvements. In the notes Leonardo resolved to draw other pictures of the same organs viewed from the back and the side. The drawing was made after 1508 as an expression of his renewed desire to explore the internal organs of the torso and abdomen: the work is a masterpiece of Leonardo's anatomical drawing, showing great improvement in his understanding of the organs displayed when compared to earlier works. Besides the arterial system the picture shows the trachea, heart, lungs, bronchi, liver, spleen, kidneys and a uterus carrying a baby.

Female Internal Organs
1508-1509
RL 12281 r
K/P 122 r

THE MOST FAMOUS...
Amongst Leonardo's anatomical studies this drawing is perhaps the most famous. The female internal organs of the abdomen and torso are located inside a human shape and drawn from a frontal view. In one of his notes Leonardo resolves to improve the drawing.

... BUT THERE IS ROOM FOR IMPROVEMENT
"Draw this demonstration sidewise, so as to inform that one part is behind the other and then draw one from behind, so as to show the blood vessels filled by the spine and heart and the main blood vessels".

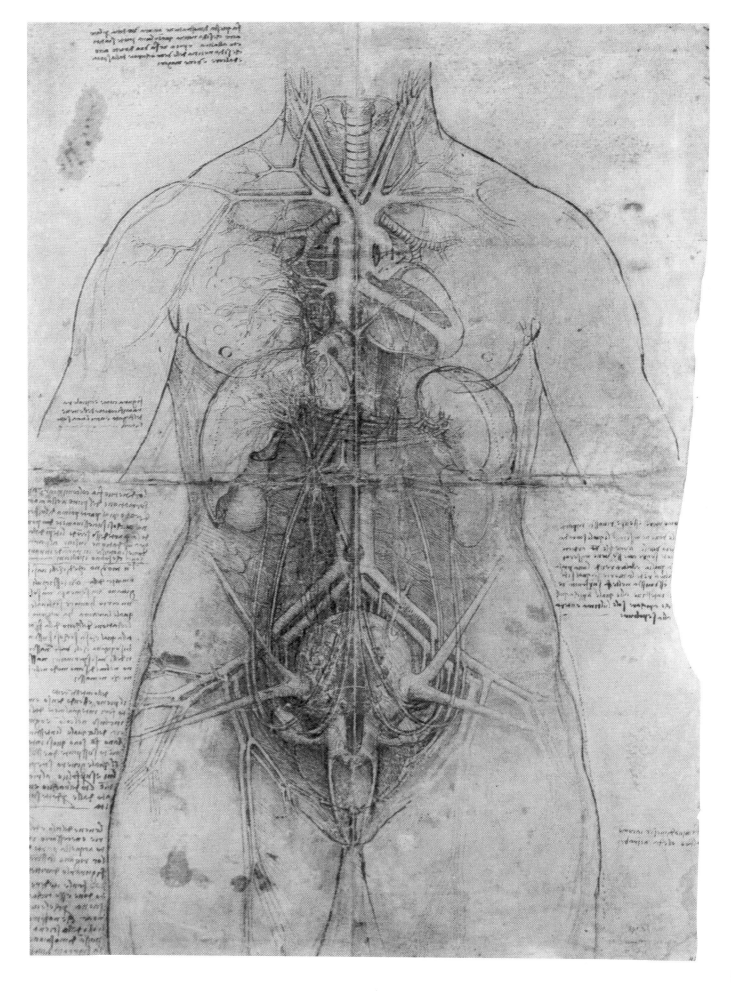

FEMALE GENITALIA AND FOETUS IN A WOMB

The folio is part of Leonardo's last embryological studies and focuses on the female genital organs and their connection with the abdominal walls and the life of the foetus in the womb. Leonardo outlined (at the top, on the right) the oblique muscles joining the abdominal wall in woman and then (at the top, centrally) drew the external genital organs clearly identifying the vulva and labia minora. Leonardo's accurate analysis of the foetus's position in the womb is extraordinary in his genre and is displayed, as was his custom, from different perspectives. In one of the notes explaining the drawing he compared the size of the womb of a woman with that of a cow and a mare concluding with a intriguing and rather ...bold remark: "woman loves the size of the male member to be as huge as possible; whilst man wishes the opposite of the genital organ of a woman".

Female Genitalia
and Foetus in a Womb
1510-1512
RL 19101 r
K/P 197 v

A Boy or a Girl?
On the same folio with reference to the shape of eggs Leonardo writes: "if they have a roundedness about them they make boys" whilst "the oblong ones make girls".

Two Distinct Drawings
Below, in the detail Leonardo draws an external representation of the female genital organs along with two distinct views of an huddled foetus.

The Wrong Inference
Leonardo writes on this folio that nature has arranged for the heel of the foetus to block any discharge of urine. Though shrewed an interpretation, it is inaccurate.

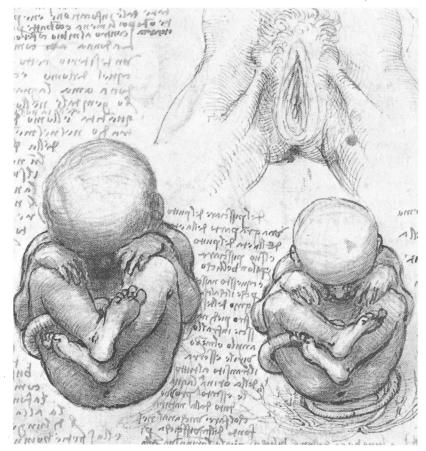

BIBLIOGRAPHY

The normative texts on Leonardo da Vinci's anatomical drawings are:
Kenneth Keele and Carlo Pedretti, *Leonardo da Vinci: Corpus degli studi anatomici nella collezione di sua maestà la Regina Elisabetta II nel Castello di Windsor*, Florence, Giunti 1984, 3 v.
Kenneth Clark and Carlo Pedretti, *The Drawings of Leonardo da Vinci in the Collection of Her Majesty the Queen at Windsor Castle* (London 1968-1969, 3 v.); Volume III of the work is almost entirely dedicated to the manuscripts and drawings in anatomy).
Among older works we recommend the following:
I manoscritti di Leonardo da Vinci della Reale Biblioteca di Windsor. Dell'Anatomia, The A Folios, published by Theodor Sabachnikoff, copied out by Giovanni Piumati, Paris 1898; *The B Folios*, in the same series, published in Turin in 1901; *The C Folios*, later published as *Notebooks in Anatomy*, edited by O.C.I. Vangensten, A. Fonahn and H. Hopstock, Christiania 1911-1916, 6 volumes.

Most anatomical drawings are collected in the following modern works: *Leonardo da Vinci on the Human Body*, edited by Charles D. O'Malley and J.B. de C.M. Saunders, New York 1952; Sigrid Esche, *Leonard da Vinci: Das anatomische Werk*, Basel 1954; P. Huard, *Léonard de Vinci: Dessins Anatomiques*, Paris 1968. Among the main commentaries to the anatomical drawings we mention: Elmer Belt, *Leonardo the Anatomist*, Kansas 1955; J. Playfair McMuerich, *Leonardo da Vinci the Anatomist*, Washington and Baltimore 1930 and Leonardo da Vinci, *The Treatise on Anatomy*, edited by A. Pazzini, Rome 1962, 3 volumes. See also Carlo Pedretti, *The Literary Works of Leonardo da Vinci. A Commentary to Jean Paul Richter's Edition*, London 1977.
Among the most recent works:
Martin Kemp, *Leonardo da Vinci. The Marvellous Work of Nature and Man*, London, Merlbourne, Toronto 1981, which has the advantage of presenting the anatomical studies whithin the wider context of Leonardo's cultural biography.
The work by Kenneth Keele, *Elements of the Science of Man*, New York-London 1983, is the most important among the latest publications on Leonardo the anatomist, topic to which the author, who is a professional medical man, has devoted most part of his energies writing also many scholarly essays. A Chastel, P. Galluzzi, C. Pedretti, *Leonardo* in "Art e Dossier" N. 12, April 1987; C. Pedretti, *Leonardo. Il disegno*, in "Art e Dossier", N. 67, April 1992; C. Pedretti, M. Cianchi, *Leonardo. I codici,* "Art e Dossier", N. 100, April 1995. Specific problems encountered in the study of the drawings are dealt with in specialized journals such as "Raccolta Vinciana" and the "Achademia Leonardi Vinci".
The following exhibition catalogues are also worthy of mention:
Leonardo da Vinci. Disegni anatomici della Biblioteca Reale di Windsor, Florence 1979.
Leonardo da Vinci. L'intuizione della natura, Florence 1983.
Gli ingegneri del Rinascimento. Da Brunelleschi a Leonardo da Vinci, Florence 1966.
As far as the relationship between art and anatomy is concerned see: Marco Bussagli, *Anatomia artistica*, Florence, 1996.

PHOTOGRAPHS